'What a thing of beauty this collection is. Traversing time and landscape, Ailsa Holland throws words like clay, to be cast in the heart and mind, to be treasured.'
— Abi Morgan (*Suffragette, The Split*)

'Here are two bookish lovers; two kinds of poem (in words, in clay); two cities, and the two kinds of work which shaped them. Here is a teapot quoting Clarice Cliff: 'having a little fun at my work doesn't make me any less of an artist.' And here is Ailsa Holland, playing with words and clay and inheritance. This collection is full of love for the places that made her the woman she is, and acknowledgement of the forces that constrain and free us all.'
— Jo Bell (*Kith, How To Be A Poet*)

'You live in the lives of poets not by what they write but by what they collect. For those who know this, and find themselves behind the pen, all is game! How better to express memory, change, youth than through pottery poetry, collage poetry and found texts? Ailsa Holland's *The Bodleian and the Bottle Ovens* is as methodologically daring as it is charming, personal, witty and incisive. We can smell the burning here and it is a city, and a jug.'
— Steven J Fowler (*Mueum, The Great Apes*)

THE BODLEIAN

AND THE

BOTTLE OVENS

AILSA HOLLAND

KU
PRESS

A catalogue of this book is available from the British Library

ISBN 978-1-90-936269-7

Typeset in Montserrat and PT Serif
Photographs ©Ailsa Holland

Editorial and Design by Kingston University MA Publishing Students: Jessica Fry, Greta Jonas, Lily Jones, Arty Prakasen

KINGSTON UNIVERSITY PRESS
Kingston University
Penrhyn Road
Kingston-upon-Thames
KT1 2EE
www.kingstonpublishing.wordpress.com
@KU_press

for Joan of Stone
mother, potter, kitchen dancer

Contents

Are they related? ...1

A Staffordshire lass ...2

Just thrown..3

Poems about childhood ...4

Nature poems ..6

Books about bottle ovens in the Bodleian Library...........................8

And not to smoke in the library ...10

What I learned at university..12

Two thousand bottle ovens won't fill themselves14

Reading rooms / 1 Old Bodleian ...15

Love poems ...16

The potbank poetess ...18

Clarice Cliff in Oxford ...20

Useful poems...22

A handy map ...24

Hovels and palaces ...26

It's all too beautiful..27

Reading rooms / 2 Hertford College (basement)28

Poems about music ...30

At the potbank..32

Trial by firing..34

Courting..35

Judith ...36

Port Meadow ...38

James Gibbs and Mrs Brodie..39

Kitchen camera ..40

Commemorative plate for the founding of the Bodleian...................42

Reading rooms / 3 Radcliffe Camera, Bodleian................................44

Chagall in Stoke-on-Trent..45

If the spirit of peace dwells anywhere...46

This young potter I gratefully remember ...48

The potter weeps into the washing up ... 49

Poems about bottle ovens ... 50

War poem ... 52

Reading rooms / 4 British Library (newspapers), Colindale.............. 54

Between the wars we went to school.. 55

Odes to mothers.. 56

Mary .. 58

The Queen of Stoke-on-Trent .. 60

The King of Oxford... 61

Silence please... 62

All you ever needed to know ... 63

Poems by 'anon'... 64

Tree of knowledge .. 66

32 celadon bowls found on the ocean floor 68

The garden is part of the library... 69

Eve.. 70

Xylarium.. 72

A poem about witches.. 74

Reading rooms / 5 British Library, St Pancras 76

We can't write if nothing's broken .. 77

The Great Strictly Pottery Come Throwdown Dancing 78

Bottle oven disco.. 80

Having a little fun at my work.. 82

There is an island ... 84

Afterword .. 86

Acknowledgements ... 89

Notes.. 90

About the author ... 94

About Kingston University Press ... 95

Are they related?

Culture

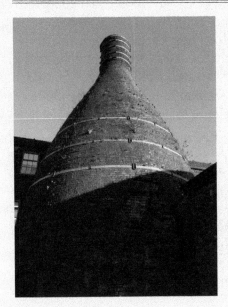

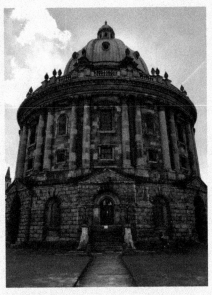

Are they related?

Left: Radcliffe Camera, Bodleian Library, University of Oxford

Right: Bottle Oven, Middleport Pottery, Burslem, Stoke-on-Trent

PHOTOGRAPHS: AILSA HOLLAND

THEY'RE SEPARATED by around 120 miles of the landscape and urbanscape of the English Midlands but what *is* the relationship between these two historical buildings — one a key part of the British contribution to world civilisation, the other the home of lots of books?

A Staffordshire lass

It was probably the oatcakes as got me into Oxford, mum's treat before my exam, in the café at Cactus Books, that spiky-staffed peace-badged island of un-Thatchered ideas, women's diaries, angry postcards. That afternoon I began to pen a path away from classes in 1970s concrete, away from clubbing at Chico's and Ritzy's, away from walks on the towpath, a path towards stone buildings who'd survived many decades called the 70s, to dancing in sweaty cellars, to a moonlit garden.

I ate an avocado, disliked sherry, drank the library, learned to write an argument into a gown and three-cornered hat. I still walked on towpaths, I missed the black-remembered kilns, I got lifted up, up each day by the paradise blue above the Radcliffe dome and the old of the books and the so many of the books and the ridiculous loveliness of this strange new world where very few knew my county let alone my town but somehow had some people like me in it, such people

Just thrown

all day they walk with intent up and down
St Giles St Aldates Walton Street
and South Parks Road and the Iffley Road

up and down to where the knowledge is
they walk to the library lab lecture
they walk to be clever then walk home

they walk straight backed and panicked
there won't be enough time today there
wasn't enough time to get clever enough

the ones on bikes will get to be clever quicker
damn them they're taking all the knowledge
home and as you walk the buildings show up

the stones you can't nothing will ever
live up to and you're not even stone
you're clay, just thrown

Poems about childhood

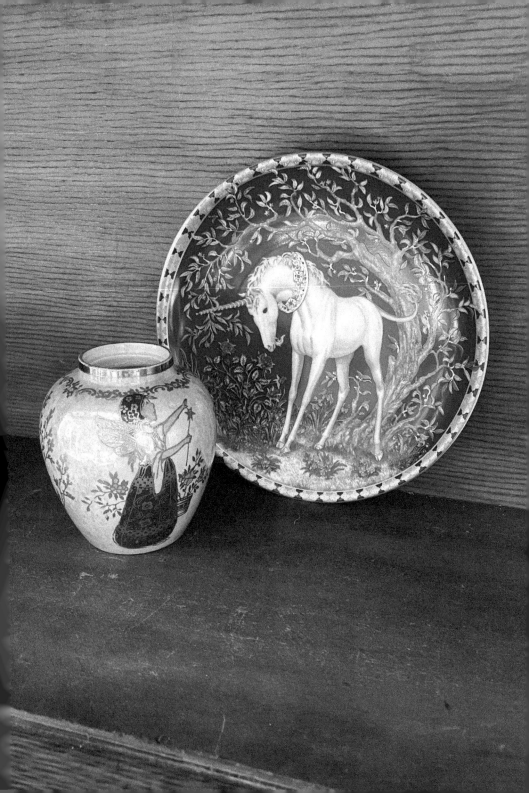

Nature poems

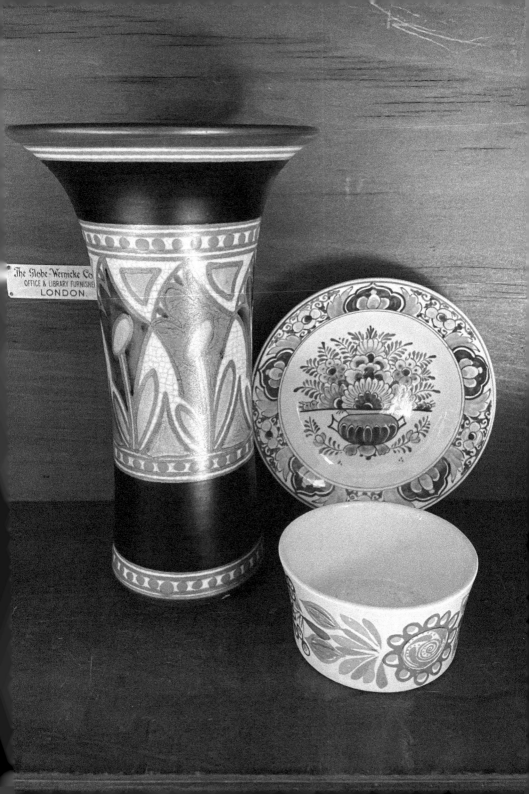

The Globe-Wernicke Co
OFFICE & LIBRARY FURNISHER
LONDON

Books about
bottle ovens in the
Bodleian Library
(out of thirteen million)

BOOK

The bottle kiln : stories & poems
Bennett, Eva (Singer), author | Ferenczy, Nicholas, author, illustrator
April 2018 | Nantwich, Cheshire : Weaver Designs | 167 pages : illustrations (black and white) ; 21 cm

Find & Request >

BOOK

A preliminary survey of the extant bottle kiln at the Fulham Pottery
Green, Christopher Maurice | Pearcey, O. H. J
[1976.] | [London] ([14 Mark Mansions, Westville Rd, W.12])} : [Fulham and Hammersmith Historical Society, Archaeological Section,] | Folder ([4] p.) : ill., 1 plan ; 30 cm

Find & Request >

BOOK

Bottle ovens and the story of the final firing
Woolliscroft, Terry, author | Woolliscroft, Pam, author | Gladstone Pottery Museum
2018 | Stoke-on-Trent : Gladstone Pottery Museum | 56 pages : illustrations (chiefly colour), portraits (chiefly colour) ; 30 cm

Find & Request >

BOOK

Bottle ovens and the story of the final f

Woolliscroft, Terry, author | Woolliscroft, Pam, a

2018 | Stoke-on-Trent : Gladstone Pottery Mus

(chiefly colour) ; 30 cm

And not to smoke
in the library

I hereby
undertake
not to remove
from the Library,
or to mark, deface,
or injure in any way,
any volume, document,
or other object belonging
to it or in its custody; not
to bring into the Library
or kindle therein any fire
or flame, and not to smoke
in the Library; and I promise
to obey all rules of the Library.
Declaration for new readers
at the Bodleian Library,
University of Oxford

What I learned at university

to read and read and read
in huge oak chairs,
while outside the window the tramps
swig sherry, and swear, and sing

to bullshit so convincingly
you believe yourself
to have got somewhere,
to have really learnt something

to have breakfast with your lover
at Brown's in the Covered Market;
to drink tea in the afternoon;
to start work when the bar closes

that night
is the best time to write
when rushing life holds its breath
that there are always sad lawyers

in the library
you can get a fag from at 3 am
that literature is an inky ocean
that history is fire

that those great leather books
those carved stone heads
weren't going to give up their wisdom to me
that love can be daffodils

in a milk bottle

Two thousand bottle ovens won't fill themselves

Walking with daughters, wives, husbands, sons,
meeting mates where street joins cobbled street
past sooted churches, terraces, oatcake shops,
boiled white pinnies under their arms,

mothering and mithering the new lad, Jack –
clay won't be rushed, ma duck, don't you mind
the gaffer when he's mardy, stay out of his road
when he's had a jar of ale or several –

walking to use their legs, arms, backs to stack
saggars in circles for firing, to hold their hands
just so, to paint flowers and bands of gold,
to make handles. Oh, their clear, tired eyes.

Flora's writing a poem in her head about lemons,
Edna's not been right since that lock-in on Monday.
Fred's planning a lunchtime cuddle with Lily
by the shord ruck. On Saturday there'll be dancing.

Reading rooms /
1 Old Bodleian

She trails her finger down the paper slips
that fill the ancient catalogues until
she finds the books she wants, then softly sings
her way up stairs that creak like those in old
romance, chooses a chair of English oak
then reads about King Horn and Gamelyn
and stares through leaded windows on a view
of spires and sky that makes her catch her breath.

The young librarian with horn-rimmed specs
walks over with her order, and a note:
Shelfmark *I like your books. King's Arms at 8?*
All day she sits and works. At 5.18
she scribbles *yes* and as she leaves
he sees the note alight like gold leaf on his desk.

Love poems

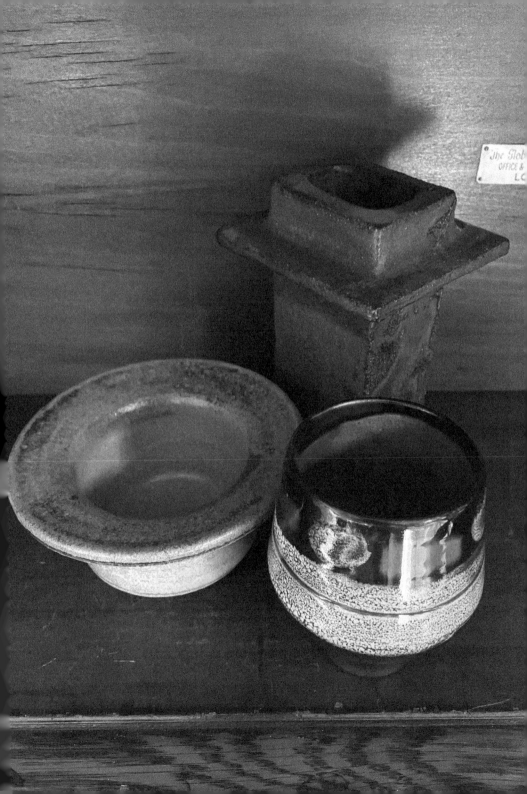

The potbank poetess

Sixty paintresses, we is, in the workshop
they call Bizarre, and the four lads, like.
The first load was sold in Oxford they said
and we said where's that like? and Miss Cliff
she got a map and showed us, said it was

over a hundred miles away, just imagine!
She got us a radio so as we can listen to music
while we's painting, and there's plays too,
lovely words, and some of the lasses sing and dance
at lunchtimes and some are ladding, go out

all dressed up like, we can all afford two coats,
and Annie goes to see Rudolph Valentino
at the Palace and Marjorie goes to the opera
up Hanley, and I buy lots of books of stories
and poems. Miss Cliff takes us all on picnics

and to the seaside, places like Llandudno,
and we do painting demos for posh folk in London,
imagine, us in London! and when we're there
I get more books, to read at lunchtimes
in a corner while the others are dancing

and now when I'm painting I dream of a town
where the sky is sunshine, not smoke,
where the library is big as a potbank.
I got a bottle of ink for Christmas, I'm going
to write and write until it's all the colours.

Clarice Cliff in Oxford

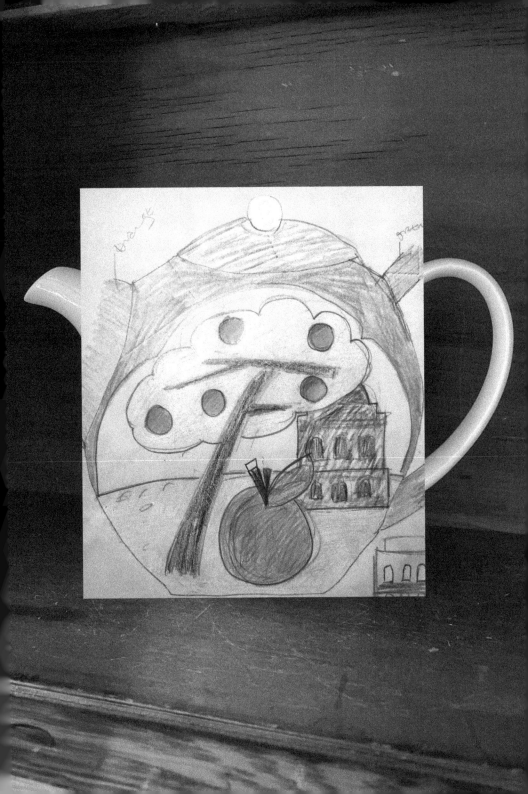

Useful poems

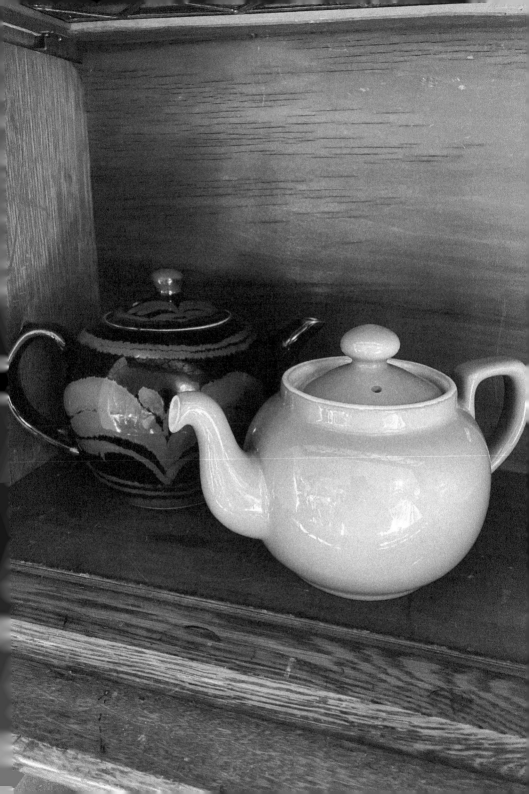

A handy map

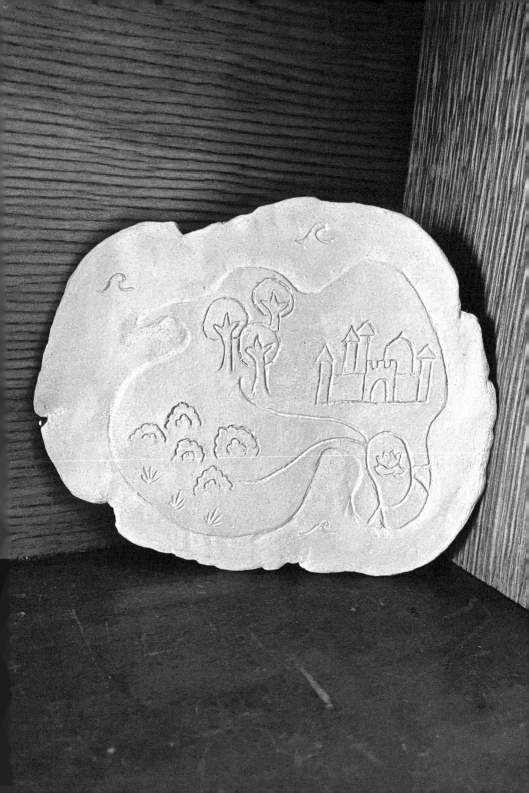

Hovels and palaces

Figure to yourself a tract of country,
the surface of which,
cut,
scarred,
burnt
and ploughed up
in every direction,
displays
a heterogeneous mass

of hovels and palaces,
farmhouses and factories,
chapels and churches,
canals and coal pits,
corn fields and brick-fields,
gardens and furnaces,
jumbled together in
'the most admirable disorder'

and you will have
a pretty correct
idea of the Potteries.
Pervade the space your fancy
has thus pictured, with
suffocating smoke, vomited forth
incessantly from innumerable fires,
and the thing
will be complete.

from *The Monthly Magazine*

It's all too beautiful

I wonder anybody does anything at Oxford
but dream and remember.

One almost expects the people to sing
instead of speaking.

It is all like an opera.

WB Yeats

Reading rooms /
2 Hertford College (basement)

'No-one in here tonight,' she whispers in
the Reference Section. 'Talk clever to me.'
Giacomo Casanova was a useless librarian.
She laughs, I smile, we peel our jackets off.
I kiss the dark below her ear. 'Your turn.'
If you put Saturn in water it would float.
Her hands draw circles in my hair. My mouth
goes to her top and tooths each button free.
Some historians regard the period 1914-1945
as a twentieth-century Thirty Years' War.
She pulls my shirt aside, traces the square
black script on my left shoulder: Silence Please.
Sunspot activity may be the primary reason
for the exquisite sound of Stradivarius violins.
The room is chill, her breath is warm across
my neck; her hair is black and smells of ink.
In a process called cold welding, two surfaces
of similar metal will strongly adhere
if brought into contact under vacuum.
With eyes and fingers, lips and tongue, I start
to catalogue her creamy vellum curves.
For Elias, society is like a group of dancers.
Each individual's gestures and movements are
synchronized, meshed with those of the others.

She reaches up behind her head and grips
the grey steel shelf (Law Journals X to Z).
'Sublime' comes from 'sub-limen' (Latin) meaning
'up to the threshold'. The sublime makes us experience
a visceral limit, takes us beyond language, to the realm
of the groan, a wordless expression of acute pleasure.

Poems about music

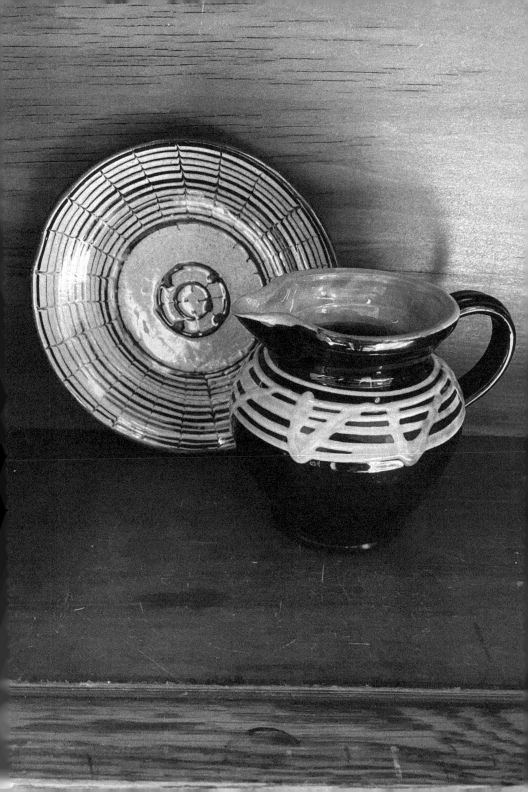

At the potbank

She loved to watch a worker
toss a shapeless lump
of pale clay on to the jolly,
with its measured motion,

and deftly, without apparent
effort, shape it
in a moment
into some familiar object.

The process looked so easy,
but she discovered that
the potter's art, like any other
demands its own apprenticeship.

But there was
an endless fascination in
watching everywhere
all round the work of creation;

formless masses whirling
swiftly into form, shapes
crystallising perpetually
out of the void

amidst a spotless whiteness;
the figures in snowy garments
manipulating white clay
which the jollies,

their mysterious agents,
sent spinning with
unswerving and accurate
industry.

Mabel C. Birchenough

Trial by firing

in the library the books are stacked
in rings and all around sit proper
readers, unaware that you exist,
you feel it first in your soles, lift
one foot then the other, bite
on your tongue so as not to cry
out not be weird everyone else
is still, the heat climbs up to
the oaken seat of this old wise
chair you've stolen from someone
cleverer then up your spine and
neck it's in your hair now flaming
it's amazing no-one else can see it
can't they smell the burning
can they only smell the old books
don't they know it's the moment
of truth when you hope to prove
porcelain or at least stoneware
please not just earthenware
only suitable for everyday
use you know that if by closing
time there's only a heap
of ash and a melted biro it will
be your own fault for being made
of the wrong sort of mud,
for doing it all wrong

Courting

It's Judith, isn't it, or is it Joan,
or do they call you Jug, sweetheart?

Have you got something in the oven, love?
Is it a bun, honey, or is it a tea set, pet?

Aren't you a clever girl?
Give us a twirl.

I think I can smell burning, Jug.
Is that you?

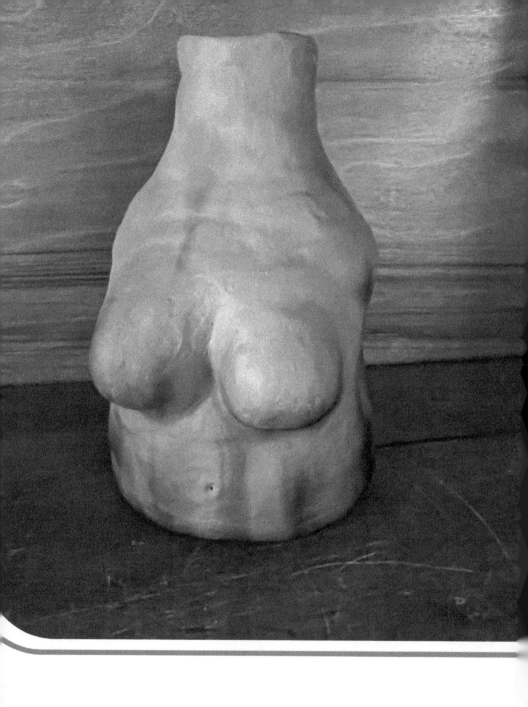

Judith

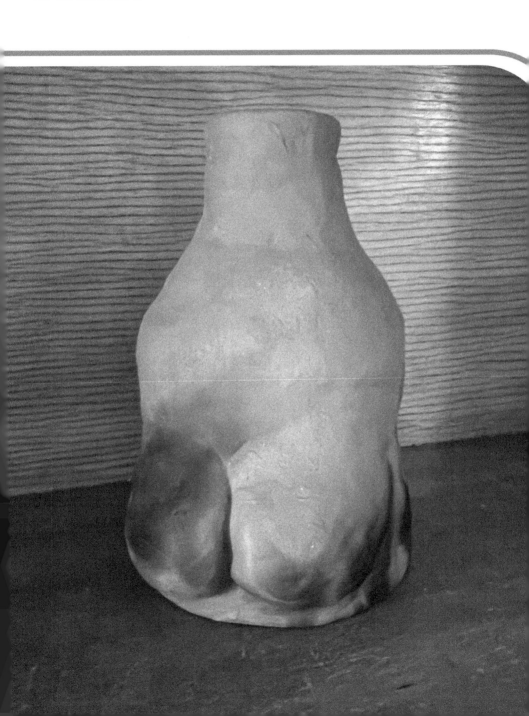

Port Meadow

The horses are proof that this is heaven.
They graze on the other side of the river
which runs just out of sight, like a secret.

We walk in the daisied green of our dreams,
talk our way towards the ruin. We stop, turn. *Horses!*
And on the horizon, the spires, wishing.

James Gibbs and Mrs Brodie

An as yet entirely unsubstantiated account claims that Scottish architect James Gibbs came up with the idea for the shape of his famous 'Camera' while sharing a cup of hot toddy one frosty night at the kitchen table with his housekeeper – and secret confidante – of many years Mrs Janet Brodie, who pointed out to him the pleasing shapes of the stoneware bread crock, porcelain jelly moulds and cream-coloured pudding bowls on the shelves around them. Perhaps they made a mock-up of the building with the materials at hand. We have attempted a reconstruction of what the first 'Radcliffe Camera' may have looked like, if this is true. In any case it seems almost certain that Mrs Brodie's diary reads: 'Library with JG. I cut windows out of Mary Kettilby (silly cow) and stuck them on with flour paste.'

We did not have a copy of Mary Kettilby's recipe collection to hand.

Kitchen camera

Commemorative plate for the founding of the Bodleian Library in 1602

THE LIBRARY was rescued from near destruction by Sir Thomas Bodley (1545-1613), a rich widow whose husband had made a fortune selling pilchards. She had married Ann Ball (née Carew, c.1560-1611), but on remarrying her money became Bodley's. When Thomas Bodley died on trading after his death, money to the library that would carry his name into posterity.

1602

Reading rooms /
3 Radcliffe Camera, Bodleian

We've made this love at every compass point
and some between, in pre- and post-work hours
on long oak tables, hard and warm, and through
the high arched windows there is sometimes sun
and sometimes rain and fog but always green.
All Soul's, St Mary's, Brasenose turn their backs
on us. At sunset their stones are smiling red,
on winter mornings blue with disapproval.
I've spent so many hours in here there's now
a space inside my head this shape, this height,
this light, where walls of books make open rooms;
so here I lie inside myself and look
at him and know that this will be the place
I'll always crawl back to, weeping, in my dreams.

Chagall in Stoke-on-Trent

He didn't paint on a firing day when smoke
from the bottle-kilns glazed the houses

and lungs. He painted a flying narrowboat
above Etruria, led by its horse, dancing.

He painted a woman, cackling over
a cup of char, her bosom glowing red.

He painted a boy with a mardy look,
a girl with a bouquet of rosebay willow herb,

a kind miner. A bottom-knocker
played the fiddle on the roof of a potbank

while saggars and oatcakes floated in the sky
and the colours he mixed were like planets.

if the spirit of peace dwells anywhere, it is in the courts and quadrangles of Oxbridge on a fine October morning

a guardian angel with a flutter of black gown
instead of white wings
regretted
in a low voice
that ladies
are only admitted to the library
if accompanied by a Fellow of the College or
furnished with a letter of introduction

That a famous library
has been cursed by a woman
is a matter
of complete indifference
to a famous library.

Venerable and calm,
with all its treasures safe
locked within its breast,
it sleeps complacently and will,
so far as I am concerned,
so sleep for ever. Never

will I wake those echoes, never
will I ask for that hospitality again,
I vowed
as I descended the steps
in anger.

Virginia Woolf

This young potter I gratefully remember

His name was William Leigh. He was then,
as in his after life, of studious habits, modest,
and upright in all his ways, and whose life
had much fragrance and sweetness in it.

He found out, from seeing me reading at nights,
that I was fond of reading and up to the time
of going to the workhouse he regularly
supplied me with books, and these

were as precious as the bread he gave us.
It was he who first opened to me the great world
of literature, and from that day I have known
'the world of books is still the world.'

Charles Shaw

The potter weeps into the washing up

She cries for all the dirty dishes of the world,
left because of a hammering at the door;
abandoned because time had run out;
smashed in the night, blanketed in dust.

She runs her forefinger over greens, blues,
browns, lets hot water bless these pots, each
her own miracle, shaped earth, hardened
by fire, dressed lovingly in glass.

She knows that others, so many, lie trapped
under bricks and beams. So few, too few,
will be salvaged. She longs to fill those
far-away cupboards, see the children at table.

Poems about bottle ovens

598

The 300 year old tradition
of firing ware in coal-fired bottle ovens
...out in the Potteries a generation ago
In August 1978
the process was revived for the last time,
...group organised by Gladstone Pottery Museum
at Sutherland Works, Longton

THIS POT
made from Staffordshire Clay
was fired there
and is therefore one of...
...to be fired
by traditional methods...
in Stoke-on...

The Globe-Wernicke Co. Ltd.
OFFICE & LIBRARY FURNISHERS
LONDON

War poem (Berlin, 1945)

Reading rooms /
4 British Library (newspapers), Colindale

They fight in whispers by the microfiche
machines. Around them sit unpassioned souls
at darkened desks, reading of strikes and kings
and holocausts in old, exhausted air.
He wishes she would see him. *Why read this stuff?*
You're not a harsh-reality girl. She
just wants to work, fucksake, hisses *It's time*
to put an end to this. Her eyes are ink.
At home he can't remember getting on
the bus, then catches sight of the battered tin
of Earl Grey Tea and throws up in the sink.
Her room is dark. She sits with open eyes,
a closed book on her lap. Her belly hurts
like being kicked; she knows what this means: blood.

Between the wars we went to school

And the teachers came back from the camps and looked
so happy to see us, as though this were a reunion
and we asked ourselves who they thought we were.
One I liked more than before, and one scared me
with her face the colour of ashes and her eyes.

They walked us to the library. The lock was rusty
but the key still worked, we pushed together, opened
the big oak doors. Our teachers smiled to smell books
through charred wood and rubble. We meant to clean
but found ourselves sitting in the dust, reading aloud

to each other *listen to this* so thirsty for new words *drink
this*. We went each day, found a wondrous tap, wiped
covers like a ritual, pushed felled cases back to standing,
found chipped mugs *best mum ever i love big books*
and a willow pattern plate covered in brick crumbs.

One teacher was sleeping there, like a guard, inside
a fort she'd made, four low walls of books, wrapped
in the bedspread her mother had sewn for a hope chest.
Where else would I go? she said, *where else can I sleep
so deep, surrounded on all sides by piles of lives*

Odes to mothers

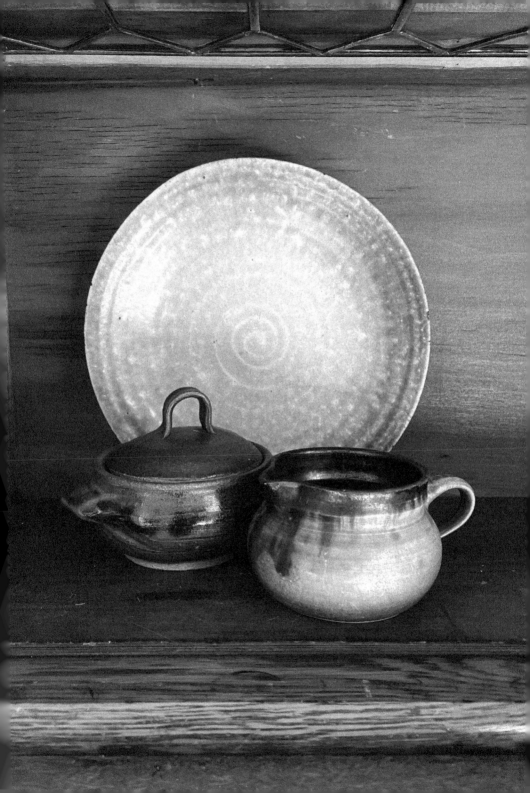

Mary

The Queen of Stoke-on-Trent

wears an old crown, gold-plated onto steel that still remembers
the furnaces at Etruria, how they burned, like home and hell.
It's cut as mismatched bottle ovens, set with diamond-shaped
potsherds, blue and white; from the top of each rises silk-
smoke, imported from Leek, silver-grey.

Her palace is a narrowboat on the timeless Trent and Mersey.
She's lived 200 years so far, fears she'll be the last to do this.
Her eldest is set on app design, the middle one makes bowls
from marl she digs herself, the youngest is a waistcoated
dancer. *Dunna mither me, me ducks,* she says to them when
busy with affairs of her six-town queendom, holding court
on a throne of blackened saggars in a yard paved with bricks,
Staffordshire blue. There's never enough money to go round,
just char, pikelets, common sense, no pretence. There's no
delusion.

There are days when she puts on her boots, walks out and up,
pops in on the Queen of the Moorlands, stops by the Woman
of the Dark Pool, gets herself two big lungfuls of air before
catching a bus back to the haphazard streets, messy and kind
and broken as love.

The King of Oxford

wears mostly green, lives down by the canal in Jericho. He walks over into Port Meadow most days, sad that Lucy's has gone, the foundry replaced by flats, he misses the weight the grime the real of it. He talks like a field of barley, like woodland, like a hidden river.

Some days he walks into town, has breakfast at Brown's in the Covered Market. He still maintains this chilly pheasant-and-rabbit-hung stronghold within the territory the invaders claimed for themselves, their stone buildings, all their books.

He likes the bright-faced women and the men who scurry as if afraid, worn-out bags under their skinny arms, but not the strutty fuckers who bray about as if they own the place, donkeys dressed as men, raised on rugger and ridicule.

But they've only been here a few hundred years and before too long they'll be gone again, sooner if the clever women have anything to do with it, and then his children won't have to clean up after them any more.

He likes the singing, mind, the first dawn in May. And he's learned a lot in the garden they made. On cold days he sits for hours in the glasshouses, gazing at the giant leaf that floats like a mossy moon.

Silence please

you're in the library, oh my god, you're here, you never thought you'd make it but here you are and it's all so fucking beautiful, Christ, the carved stone and everything of oak and the view through the windows and the beautiful fucking windows, and floor-to-ceiling books, old books, so old, and it smells so gorgeous, so quality and yet here you are, fresh out of Sixth Form wearing this library like a coat you thought you could never afford and at the top of the walls there are bearded men, all dark haired, all bearded, all men, men who knew so much they got to wear the library permanently, to become part of it, to be the trim around the collar, saying *welcome to where the knowledge lives* and belonging here is the beginning of everything

weeks pass eight at a time and the colours of stone and oak and blue sky settle on to you, a gown, a second skin, the old books smell is an everyday smell and unpacking your bag downstairs and walking up feels like coming home this will always be one of your homes now, the librarians recognize you and the one with horn-rimmed specs even smiles sometimes and you look at the frieze of men again and again, still all bearded, all still men, and there are lots of days where you try not to look at them there are days when they say *the truth may not set you free but alight like Joan or bleeding like Mary or drowned like Virginia or breathless like Sylvia, some will be professors and some will be witches it's your choice silence please*

All you ever needed to know

every library is built over hell,
so you can look for heaven inside it

on the top floor you can climb an oak ladder
up, up to the volumes not taken

you can stand on the seventh rung, stretch left,
land your hand on a shabby brown book

and take it, hold it hard against your chest
as you step down, rest it on a table, open it up

and find a tree, green, red and gold, bold
against the mother of costly skies

Poems by 'anon'

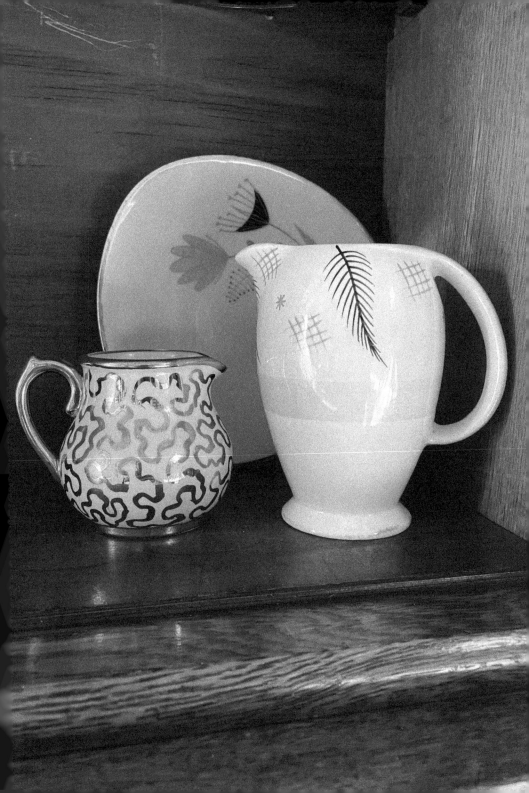

Tree of knowledge

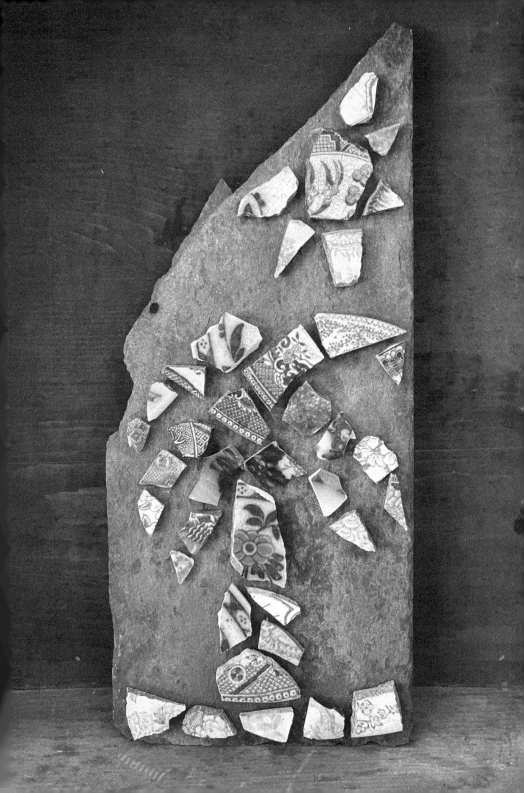

32 celadon bowls found on the ocean floor

have survived time and storms, loved in their wooden crate,
they've held out a thousand years waiting for someone
to dive deep to find them, haul them up to air

> there was a time when my mother stopped
> making pots, stopped spending time
> with celadon glaze, one of her favourites

I wish they weren't in the British Museum, they look
as though they'd still like to be unpacked, I wish
someone could free them, fill them with soup or flowers

The garden is part of the library

Eve catalogues the plants, collects
slim volumes of wood, makes books
of bark, works out what poisons
and what heals, knows the silver birch
likes to make fire, finds a claggy patch

by the *Ficus carica* where the earth
is firm as muscle, scoops out enough
to make a man—to work next to her,
fit inside her—lays him to dry in the sun,
then falls asleep, exhausted by creation,

wakes to find him breathing, over her,
within a year he's calling himself Head
Botanist and she's at home, loving
her exquisite daughter Judith, missing
the ferns, the foxgloves, the hellebores.

Xylarium

there's wisdom in wood, you can

Ash Baobab Cedar

rub thoughts together to make a fire,

Dogwood Elder Fir

find which ones burn hottest, which

Ginkgo Hawthorn Ivy

idea makes a witch, which wood

Juniper Lime Magnolia

is witch wood. Eve scratched

Nutmeg Oak Plane

her first words into clay then wrote

Quince Rowan Sycamore

rhymes on bark, made a library,

Teak Umbrella Viburnum

worked out that beeches make books

Willow Xylosma Yew Zelkova

if you put the leaves in order

73

A poem about witches

Reading rooms /
5 British Library, St Pancras

They wear white gloves and speak in cotton tones.
He can't believe it was his job today
to bring the manuscript, can't believe he gets
to sit with her in awe of this rare thing,
its quiet vellum leaves, its square black script,
its breathing pigments: red from dragonblood,
bright grassy green from verdigris and blue
from azurite, its gold leaf like the sun.

He finds he can exhale and then draw breath.
She feels her wooden chair is like a bed.
It might be her, or him, who looks into
a bookish face (once-loved, still young) and speaks:
Without the exquisite proximity
of you, your body, your brain, all words print white.

We can't write if nothing's broken

if you drop a mug use the pieces
to cast your vote on, let them decide
who's in who's out who's
on our side who's ostracised

if you drop a plate use the pieces
to make notes on, they'll keep
longer than paper, potsherds tell
their own story, the oldest story

think if there was a fire if you had
to leave fast what would you grab
which broken old thing would you
grip to your chest as you ran

The Great Strictly Pottery
Come Throwdown Dancing

what was the chance
that clay
would learn to dance?

what was the chance
that a lump,
unseen among the rest,

would be taken through
all those steps,
lifts, leaps, be thrown, spun

what was the chance
it would find inside itself shapes
it didn't know were there,

feel what it is to grow tall,
make straight lines,
make curves, what it is

to shine, feel as at home
under the glitter ball
as in the workshop —

at the end of a long day
it's all about work,
it's all about fire,

it's all about muscles
and fingertips, beauty
and despair,

it's about a longed-for
family no one
wants to leave

Bottle oven disco

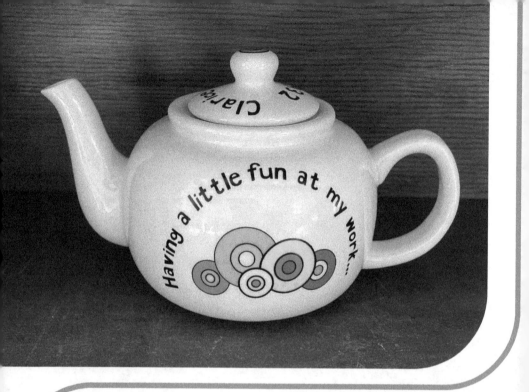

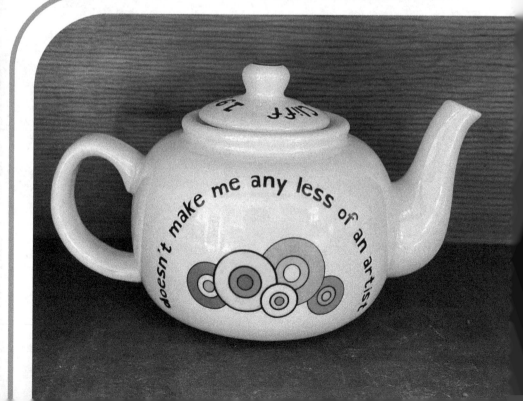

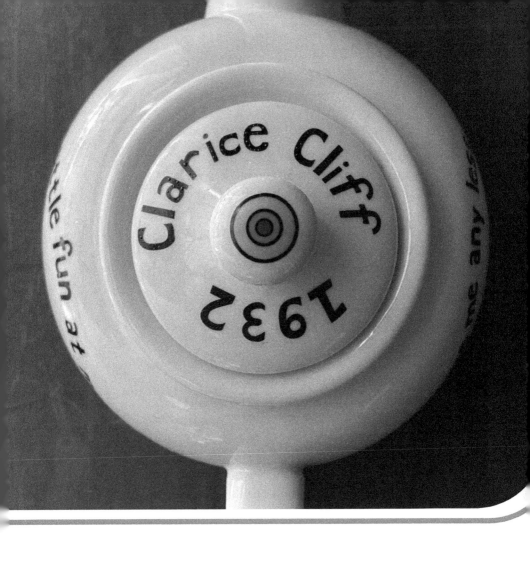

Having a little fun
at my work

There is an island

and there is a map of the island
and that map is in an old book
and that book is in a panelled library

and that library is in a city of towers
of domes of hovels of spires
of giant ovens like queens

and that city is on the island
with woods, moors and gardens,
cliffs and caves, circles of stone

and they're all on the map
with their names—their lovely names—
so I must find the city, the library, the book,

must find the map by finding the island
without it. I expect there will be monsters
and storms. There will be stars like words.

Afterword

By now the reader will have their own take on the premise that the Radcliffe Camera, part of Oxford's Bodleian Library, looks like and has things in common with the bottle ovens in Stoke-on-Trent.

This is in one sense a playful project, but very real to me, who was in 1987 a young woman from a Staffordshire comprehensive, looking for something familiar in the extraordinary universe that is Oxford University. It's an experience I'm still processing after over 30 years.

And the premise enables me to ask the question — in what does civilisation reside? In pots or in books? Why are the people who make one kind of thing so exalted over the people who make the other?

It's obviously a class question; the knowledge and art of those who worked in the ceramics industry of the Potteries are overlooked because they themselves are not wealthy or venerated.

Thinking about pottery takes us right back to prehistory; potsherds are among the oldest surviving evidence of human civilisations. And the form of the bottle ovens is female, reminiscent of ancient 'Venus' figurines; the bottle ovens have been written about as women, spinsterish or curvaceous in form, capricious in their ways.

So I also play with the idea of women as vessels — 'bun in the oven', the name Judith shortened to 'Jug' — and what it is that we are supposed to, allowed to, contain. We can cook up cakes, babies, maybe even pots, but are we allowed to contain knowledge? What happens to women who want to fill themselves with books? Who want to be the Radcliffe Camera as well as the (bottle) oven?

And so the playfulness has a dark side because we know that women who aspire to own knowledge, to use that knowledge to contradict an accepted

narrative, even to claim unique knowledge — can be called witches, can end up silenced or dead. We can smell smoke.

We know that women are also silenced by being ignored by historians, so to reinstate a woman written out of the history of the Bodleian Library I tell the story of Mrs Ann Bodley on a plate. It was the money made by her and her first husband, selling pilchards, that funded the whole bibliophilic enterprise.

I keep things mostly playful so people will still want to read the poems. I wouldn't want to be too strident about what women still have to negotiate when we speak or write, whether it's online, in newspapers or in poetry books.

And because, like Clarice Cliff, I want to have a little fun.

Ailsa Holland, 2023

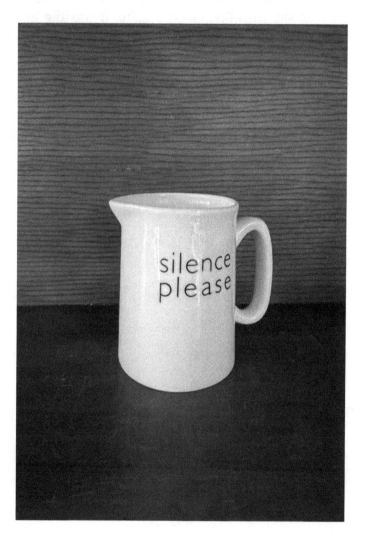

Acknowledgements

This book would never have become anything other than a bottle-oven-shaped glint in my eye were it not for the magnificent people of Popogrou. Thanks go especially to Steve Fowler and Laura Davis and also — in no particular order — to Bob Brightt, Martin Wakefield, Lucy Furlong, Susie Campbell, Vicki Kaye, Simon Tyrrell, Stephen Sunderland, Patrick Cosgrove, Chris Kerr and Lisa Blackwell. It is miraculous to be able to talk about the things that go round my head and not feel weird. Thank you all for your enthusiasm and your invaluable feedback.

Many thanks too to the folks of Kingston University Press, Emma Tait and Team Bottle Oven — Jess Fry, Arty Prakasen, Greta Jonas, Lily Jones — who threw themselves into this project with heart and soul and had such inspiring ideas. It's been an absolute pleasure to work with you all.

Thank you to Macclesfield friends, *Pottery Throwdown* fans all, who've listened to me talk about this over many cups of tea.

Thank you to my mum, Joan, who used to make great pots on a wheel in the cellar, and to my dad, Peter, who loves old books.

And of course and always, love and thanks to my lovely husband Robbi, and to Lili and Ben who are finding their art and give me such joy.

Earlier versions of some of these poems were published in my pamphlet *Twenty-Four Miles Up* (2017). 'The Potter Weeps Into the Washing Up' was published in *Firth* magazine (Issue 1, May 2018).

Notes

Word poems and clay poems by Ailsa Holland unless otherwise noted.

page 4 — Poems about childhood
plate: 'The Unicorn in the Magical Garden', design by Charlotte and William Hallett, made by Hutschenreuther, Germany
vase: Crown Devon Lustrine Fielding's, Stoke-on-Trent, England

page 6 — Nature poems
vase: Gouda, Holland
plate: Delft, Holland
sugar bowl: Turi Design, Figgjo Flint, Norway

page 14 — Two thousand bottle ovens won't fill themselves
mithering = bothering; duck = term of endearment; gaffer = foreman; mardy = moody; saggars = stoneware crates in which pots were stacked for firing; shord ruck = pile of broken pottery, shards

page 16 — Love poems
brown vase: Ailsa Holland
blue pot: Ailsa Holland
goblet: studio pottery, maker unknown

page 18 — The potbank poetess
Bizarre was the name given to the workshop (and ceramics line) run by Clarice Cliff. Ladding = courting, going out with a boy.
Clarice Cliff (1899-1972) was a working-class woman from Tunstall who became Art Director at Newport Pottery and A. J. Wilkinson, Burslem. She was a pioneer, the inventor of jazz ceramics.
'Everything Miss Cliff sees, or (as she says) "thinks of as she goes along," suggests a new design to this poet in pottery.'
From 'Women Want Cheerful China', *Modern Home*, November 1930.

Cited in Lynn Knight, *Clarice Cliff* (2005), p. 142.

page 22 — Useful poems
green teapot: Denby, Derbyshire
brown/black teapot: Derek Ems, one of the best teapot makers ever

page 26 — Hovels and palaces
From *The Monthly Magazine*, 1 November 1823. Title and line breaks mine.
From https://bottleoven.blogspot.com.

page 27 — It's all too beautiful
WB Yeats in a letter to Katharine Tynan (1888). Title and line breaks mine.
From G.R. Evans, *The University of Oxford: A New History* (2010).

page 28 — Reading rooms / 2 Hertford College (basement)
For Elias on individuals in society as dancers see Norbert Elias, *The Society of Individuals* (1987).

page 30 — Poems about music
plate: Tom Atkins
jug: 'HP' on base, unknown potter

page 32 — At the potbank
From Mabel C. Birchenough, *Potsherds* (1898), p. 81. Title and line breaks mine.
Mabel Charlotte Birchenough (née Bradley, 1860-1936) was a British novelist and critic, author of *Disturbing Elements* (1896), *Potsherds* (1898) and *Private Bobs and the New Recruit* (1901). Her father, George Granville Bradley, was Master of University College Oxford 1870-1881; in 1878 he became the first chairman of the Association for the Education of Women, which promoted the education of women at the university. Aged 10-21 Birchenough lived at University College; her first novel is about women at an Oxford college; her daughter Elizabeth Mabel Birchenough went up to Oxford in 1913.

page 39 — James Gibbs and Mrs Brodie
The Radcliffe Camera was designed by James Gibbs (1682-1754) and built between 1737 and 1749. In contrast, most bottle ovens were built

'by eye', 'based on the experience of the oven builder and the particular requirements of the factory owner.' https://bottleoven.blogspot.com.
A Collection of Above Three Hundred Receipts in Cookery, Physick and Surgery by Mary Kettilby and others was first published in 1714 by Richard Wilkin.

page 40 — Kitchen camera
plates: Denby, Derbyshire and Heron Cross pottery, Stoke-on-Trent
serving dish: Wedgwood
Bunnikins bowl: Royal Doulton

page 42 — Commemorative plate
Text reads: 'The Library was rescued from near destruction by Sir Thomas Bodley (1545-1613), who had married Ann Ball (née Carew, c. 1550-1611), a rich widow whose husband had made a fortune selling pilchards. She had carried on trading after his death but on remarrying her money became Bodley's. When Thomas Bodley died he left all 'his' money to the library that would carry his name into posterity.'
Ann Carew was born in Bristol to Richard Carew, Mayor. After her marriage to Nicholas Ball, MP and Mayor of Totnes, she lived in Totnes, Devon. Bodley and Ann married on 19 July 1586. Bodley didn't leave any money to Ann's children by her previous marriage.
Considering how Ann Carew/Ball/Bodley has disappeared from the historical record it is pleasing that there is now an Ann Ball Bodley Fellowship in Women's History, which encourages researchers 'to come to Oxford and use Bodleian Libraries collections to advance their scholarship in women's history, of any geographical area and historical period.'

page 46 — If the spirit of peace dwells anywhere
From Virginia Woolf, *A Room of One's Own* (1929). Title and line breaks mine.

page 48 — This young potter I gratefully remember
From Charles Shaw, *When I Was A Child* (1903), p. 93. Title and line breaks mine.
Charles Shaw (1832-1906) was an English potter, born in Tunstall, Staffordshire.

page 50 — Poems about bottle ovens
tyg: Gladstone Pottery Museum. Text reads: 'The 300 year old tradition of firing ware in coal-fired bottle ovens died out in the Potteries a generation ago. In August 1978 the process was revived for the last time in a firing organised by Gladstone Pottery Museum at Sutherland Works, Longton. THIS POT made from Staffordshire Clay was fired there and is therefore one of the very last to be fired by traditional methods, in a bottle oven, in Stoke-on-Trent.'
vase: sculpta ceramics, Stoke-on-Trent
mug: Moorland Pottery, Burslem, Stoke-on-Trent

page 52 — War poem
0.75l jug: maker unknown, possibly German

page 54 — Reading rooms / 4 British Library (newspapers), Colindale
The British Library Newspapers Library isn't housed at Colindale anymore; the collection is now digitised.

page 56 — Odes to mothers
plate: Japanese, maker unknown
lidded pot: Joan Holland
jug: maker unknown

page 64 — Poems by 'anon'
plate: Winterling, Marktleuthen, Bavaria, Germany
tall jug: Balmoral, Burleigh, Burslem, Stoke-on-Trent
short jug: Sudlow's, Burslem, Stoke-on-Trent

page 72 — Xylarium
For more information on the Oxford University Xylarium see https://herbaria.plants.ox.ac.uk/bol/oxford/Xylarium.

page 74 — A poem about witches
'The Gossipers' from Mexico, whistling clay sculpture, artist unknown

page 88 — small 'silence please' jug
Designed by REPEAT REPEAT, from the Bodleian Library Shop

Award-winning poet and visual poet Ailsa Holland published her first pamphlet, *Twenty-Four Miles Up*, in 2017 with support from Arts Council England. Ailsa's poems have appeared in anthologies including *The Tree Line* (2017) and *MAP: Poems After William Smith's Geological Map of 1815* (2015) and in journals such as *The Rialto, Under the Radar, Bare Fiction* and *3:AM*. Ailsa was Artist-in-Residence for Macclesfield's Barnaby Festival in 2016; she has collaborated with artists' studio Twentysevenb on several exhibitions including *How Did It Get So Dark?* (2018-19). Ailsa is co-creator of the feminist history Twitter project @OnThisDayShe and co-author of *On This Day She: Putting Women Back Into History, One Day At A Time* (2021). She is Director of Moormaid Press.

About Kingston University Press

Kingston University Press has been publishing high-quality commercial and academic titles since 2009. Our list has always reflected the diverse nature of the student and academic bodies at the university in ways that are designed to impact on debate, to hear new voices, to generate mutual understanding and to complement the values to which the university is committed.

While keeping true to our original mission, and maintaining our wide-ranging backlist titles, our most recent publishing focuses on bringing to the fore voices past and present that reflect and appeal to our community at the university as well as the wider reading community of readers and writers in Kingston, the UK and beyond.

As well as publishing the work of writers and poets from the university's vibrant writing community, we also partner with other disciplines around the university, and organisations from our local community, to bring their content to a wider readership, and publish our own editions of older works.

Our books are all edited, designed and produced by students on Kingston University's MA and BA Publishing courses, whose creativity and publishing skills bring the projects to life.

Follow us on Twitter @KU_press and Instagram @kingstonuniversitypress